South Haven
Poetry Book

Lakiesha Cole

authorHOUSE

AuthorHouse™
1663 Liberty Drive
Bloomington, IN 47403
www.authorhouse.com
Phone: 1 (800) 839-8640

Published by AuthorHouse 05/13/2020

ISBN: 978-1-7283-6130-7 (sc)
ISBN: 978-1-7283-6129-1 (e)

Print information available on the last page.

This book is printed on acid-free paper.

Contents

Dust To Gold

Once looked at
Like a dusty book
On a shelf
That never gets read
Now successful
Like a hit record
On the radio
That just went gold
Never underestimate
The dirt on the ground
You might be walking on
A gold mine

Mistakes

Everyone have made mistakes
In their life
Some that we wish we could
Go back and correct
Or even erase
With a pencil
But we have learned
From our mistakes
So there's no repeating
Or going back
Only learned lessons

A Letter To Love

Dear Love,
Are you hiding from me or you're
just not ready to find me?
I've been searching for you here and there
And you're neither here nor there
Nowhere to be found
I understand now at the right time
We will find each other
Until that time and date
Keep your heart sacred for me
As I will keep my heart sacred and open for you
Sincerely,
Yours Truly

Peace On Earth

Come and let us
Gather together on earth
Old ways has departed
Rejoicing has started
As one accord
Leaving our differences aside
Standing by each other's side
We will declare
Peace on earth

True Friends

True friends are like jewels
Diamonds and pearls
That we never want to lose
Always there to listen
To give good advice
With a little spice
Through break ups
And ups and downs
That life may take us through
You got my back
And I have yours
When you're down
Here is my hand
To lift you up

Black Sheep

Normally sheeps are white
Looking alike
Without any patches or spots
Can you spot a different one?
Look closely
It's the rare black one
That is different from the rest
It stands out not only because of the
color
But the way it moves
Not with the rest but is the best
So count it all joy
When you're different from the rest

Raging Jealousy

One of the most dangerous spirit
A person can have
On the inside
Let it grow for so long
And prolong
It can make a person
Steal from another
Destroy another
Lie on another
Or even hate another
Watch out for it
It can creep upon you
With a fake congratulations, smile,
hand shake, and hug
While laying dormat
Inside a person
Like a rug

Love At First Sight

Never seen each other
In plain sight
Face to face
Let's not waste time
Getting to know each other
At a fast pace
Does physical attraction
Mean we love each other?
Yes it's strange
But the love is outer range

Acceptance Letter

It's not the acceptance letter
into a prestigious college
This is something even greater
It's the acceptance into
The kingdom of heaven
When I saw my name
On the scroll
I was thrilled
And God said
Well done
"Thy Good and Faithful Servant"

Life

In life we get tossed
To and fro
By the winds
High winds
Low winds
But after the rumble and tumble
We're back on solid ground

Pause, Rewind, Fast-Forward

Hit the pause button
When you want to react to someone
in a negative way
Before that reaction leads you far away
Hit the rewind button
To look at the times
That the simple things in life made you happy
Hit the fast forward button
To past onward away from obstacles and hard times
Only if life had these buttons
Life would be a remote

Beautiful and Wonderfully Made

Finely carved out
In the master's hands
Molded gently
With smooth clay
Layered together
Piece by piece
The finished product
A masterpiece

Silent Suffering

Each day people are walking around
Suffering with depression, illnesses,
disappoints, and loss of a love one
All of these things are eating them up on
the inside
But you would never know it
Their smiles covers it up on the outside
Instead of looking down and judging
them
Lend a listening ear and a helping hand
Without fear
To hear
It might save a life

My Love

My Love tells me
He loves me
Everyday
He takes me out
To the finest restaurants
And I don't have to pay
We pray together
Asking God to keep us together
There for
No man, nor woman
Can seperate
What God has his hands on

Forgiveness

It's the hardest thing to do
In life
When someone has hurt you
So badly
Sadly, holding on to unforgiveness
In our hearts
Hurts the most
A fragmented heart
Can't perform well
You might as well
Forgive them
Before it tears you up
On the inside
Put your pride aside
And heal that wound
Be free to forgive

Gossip

Spreads like California wild fires
Within minutes
From person to person
Ear to ear
Without fear of hurting anyone
With lies or truth
It just wants to be heard and known
Better to tame that fire
Before it gets too explosive to handle
To some people it may be implosive

Keep On Trucking

No matter what your going through
Keep on trucking
No matter how down you get
Keep on trucking
No matter how hard it gets
Keep on trucking
At the end of the road
You will reach your destination
Only if you keep on trucking

I Love Being Me

You don't have to like or love me
But I do
Can you see the difference in me
Every part of me is unique
The way I talk
The way I walk
The way I laugh
The way I look
It's all apart of me
There wasn't a mistake creating me
That's why I love being me

Wicked Neighbors

Watch them close
The ones that are living next door to you
Waving with a smile
All along
Plotting against you behind your back
Jealous of you because of something that they lack
Ready to destroy you at the drop of a dime
In due time
Their true colors will come out
Just another slime in the green grass

Believe

The impossible is possible
If only you would believe
You can achieve your dreams
If only you would believe
You can be successful
If only you would believe
The hard times are coming to an end
If only you would believe
There is a solution to your problems
If only you would believe

Mr. Too Good To Be True

When this man walks in the room
He commands the attention
Not seeking it though
He deserves the recognition
He has a smile that lights up the room
And a wife that stays on his mind
Where can you find
A loyal hard working man
Provider and protector
No need for a lie detector

Changes

The seasons change
Time of the day change
Years change
Your age change
You change channels on the tv
So what you are going through
Will also change

Secret Service Angels

They are all around us
Heavenly beings
With lovely wings
From God almighty
Released to
Defend, fight, and protect us
From evil
As we lay
Day and night

Our Wedding Day

This is our special day
A day to remember
In September
The church is filled
With our family and friends
Kids are playing around
In the church
The cheerfulness and love never ends
Our day has finally come
It's time to say
"I do"

A Rose For You

A rose for you all the times that I
didn't say I love you
A rose for you to show how much I
miss you
A rose for you all the times you
cried
A rose for you all the times you
made me laugh
A rose for you to ease the pain
A rose for you on the days you
didn't complain
A rose for you because you are
special to me
A rose for you because you are
beautiful to me
A rose for you to brighten up your
day

Time Away

There is a time and season
Without a reason
To get away, get refreshed
And get our thoughts together
Away from all the pressures of life
That runs through our minds
On a daily basis
Lets go to an oasis
On an island with sun and fun
Leaving the thoughts of negativity
Behind us
The sun is shining with positivity

Never Give Up

No matter how things look
Never give up
On your dreams
You're almost there
At the finish line
People are cheering you on
Waiting for you to finish strong
The gold medal is yours
Only if you keep going
You can do it!

Southern Girl

Her charm is stronger
Than a lucky charm
On St. Patrick's Day
And a smile that is brighter
Than the sun
At noon day
She works hard
And is always there
To lend a helping hand
Even though struggles and hard times
May come and go
She always remain strong

Gone But Not Forgotten

Just want you to know that I love and miss you
Remembering you teaching me how to ride a bike
And me falling off
I know you are in a better place
No worries
No pain
When you left
I cried and cried
Asking God why wasn't my prayers answered
Then I realized
It was time for you to go home
To be with the Lord
In paradise
Where the good live for enternity

A Mother's Prayer

Dear God,
As I pray
Before I lay
I ask that you
Will protect my children
In the spiritual realm
As well as the physical realm
As they go through life's journey
On their way
There are lessons to be learned
And money to be earned
God lead them on the right path
Which leads to everlasting life

Printed in the United States
By Bookmasters